BELTS FOR BEGINNERS

Comprehensive Guide To Choosing, Using, Maintaining Various Types Of Cummerbund For Fashion, Utility, And Fitness

ALFORD BARTELL

© [2024] [ALFORD BARTELL].

All rights reserved.

No part of this publication may be reproduced, distributed, or transmitted in any form or by any means, including photocopying, recording, or other electronic or mechanical methods, without the author's prior written permission, with the exception of brief quotations in critical reviews and certain other noncommercial uses permitted by copyright law.

DISCLAIMER

The author of this book is not linked, associated, authorized, sponsored, or otherwise related to any corporation, business, or person mentioned in this book. This book was written based on the author's expertise, insight, and personal experiences. The material given is intended for educational and informative purposes only and

should not be construed as professional advice. The author and publisher accept no responsibility or liability for any mistakes or omissions in the contents of this book. All thoughts stated are solely those of the author and do not represent the views of any organizations.

Table of Contents

CHAPTER ONE ... 15
 Introduction To Belts ... 15
 Definition And Purpose Of Belts 15
 Historical Evolution Of Belts 16
 Different Types Of Belts 17
 1. Dress Belts: ... 17
 2. Casual Belts: ... 17
 3. Utility Belts: .. 18
 4. Western Belts: .. 18
 Importance In Fashion And Functionality 19
 Overview Of Belt Materials 20
 1. Leather: ... 20
 2. Fabric: .. 20
 3. Metal: ... 20
 4. Synthetic Materials: 21

CHAPTER TWO .. 23
 Choosing The Right Belt 23
 Determining Your Belt Size 23
 Matching Belts With Outfits 24

Types Of Belt Buckles And Their Uses............26

Leather Vs. Fabric Belts: Pros And Cons27

Tips For Selecting A Belt For Different Occasions ...28

CHAPTER THREE ...31

Understanding Belt Materials..........................31

Leather: Types And Qualities..........................31

 Understanding Leather Types.......................31

 Selecting Leather Quality32

 Crafting Your Leather Belt...........................33

Fabric: Varieties And Uses33

 Exploring Fabric Types33

 Choosing Fabric for Belts..............................34

 Creating a Fabric Belt...................................35

Synthetic Materials: Advantages And Disadvantages ...36

 Understanding Synthetic Materials..............36

 Weighing the Pros and Cons........................37

 Making a Synthetic Belt37

Metal Belts And Their Applications.................38

 Exploring Metal Belts38

Choosing Metal for Belts 39
Crafting a Metal Belt 39
How To Care For Different Belt Materials 40
General Care Tips ... 40
Storage and Handling 41

CHAPTER FOUR .. 43
Belt Design And Styles 43
Classic Belts: Features And Uses 43
Fashion Belts: Trends And Popular Styles 45
Functional Belts: Utility And Practicality 47
Decorative Belts: Adding Flair To Your Outfit 48
Belt Trends Across Different Decades 50

CHAPTER FIVE ... 53
How To Properly Wear A Belt 53
Proper Belt Fit And Adjustments 53
Common Mistakes To Avoid 54
Belt Placement For Different Outfits 56
How To Match Belts With Accessories 58
Belt-Wearing Tips For Different Body Types .. 59

CHAPTER SIX ... 61
Belt Care And Maintenance 61

Cleaning Leather Belts ... 61
Storing Belts Properly .. 62
Repairing Common Belt Issues 64
Preventing Wear And Tear 65
Extending The Life Of Your Belts 67

CHAPTER SEVEN ... 69
DIY Belt Customization 69
Tools And Materials Needed 69
Simple Techniques For Personalizing Belts 70
Adding Decorative Elements 71
Adjusting Belt Length At Home 73
Ideas For Creative Belt Projects 74

CHAPTER EIGHT .. 77
Buying Belts: What To Look For 77
Identifying Quality Belt Construction 77
Evaluating Belt Price Vs. Value 79
Understanding Brand Differences 80
Where To Buy Belts: Online Vs. In-Store 82
Signs Of A Genuine Belt 84

CHAPTER NINE .. 87
Belts For Different Professions And Activities 87

Belts For Work wear And Uniforms................87
 Introduction ...87
 Choosing the Right Belt87
 Practical Application88
 DIY Tips ..89
Belts For Sports And Outdoor Activities89
 Introduction ...89
 Choosing the Right Belt90
 Practical Application90
 DIY Tips ..91
Fashion Belts For Social Events........................91
 Introduction ...91
 Choosing the Right Belt92
 Practical Application92
 DIY Tips ..93
Belts For Formal Occasions...............................93
 Introduction ...93
 Choosing the Right Belt94
 Practical Application94
 DIY Tips ..95
Specialized Belts For Safety And Utility95

Introduction .. 95
Choosing the Right Belt 96
Practical Application 96
DIY Tips ... 97
CHAPTER TEN .. 99
Belt Trends And Innovations 99
Current Trends In Belt Fashion 99
Technological Innovations In Belt Design 101
Sustainable And Eco-Friendly Belt Options .. 103
Future Trends In Belt Materials And Design 104
How To Stay Updated With Belt Trends 106
CONCLUSION ... 108
THE END .. 112

ABOUT THIS BOOK

This book "Belts" offers a comprehensive exploration of this essential accessory, bridging both its functional and fashionable roles. Starting with a detailed introduction, readers are guided through the fundamental definition and purpose of belts, their historical evolution, and the wide array of belt types available today. This foundational understanding highlights not only the versatility of belts but also their significance in both everyday functionality and high fashion.

When it comes to selecting the right belt, this book provides invaluable insights into determining the perfect size and matching belts to various outfits. It delves into the different types of belt buckles and their uses, comparing the benefits and drawbacks of leather versus fabric belts.

Practical tips are offered to ensure that readers make informed choices for different occasions, enhancing both their style and comfort.

This book further explores the diverse materials used in belt manufacturing. It examines leather, fabric, synthetic materials, and metal belts, discussing their unique properties, advantages, and care requirements. Understanding these materials equips readers with the knowledge to choose belts that best suit their needs and preferences.

Design and style are central themes in this guide, with an in-depth look at classic, fashion-forward, functional, and decorative belts. It discusses how these designs have evolved and how they contribute to personal style and practicality. Whether readers are looking to make a statement or enhance their daily wardrobe, this section

provides a wealth of information on contemporary trends and timeless pieces.

This book also addresses the practical aspects of wearing a belt, including achieving the proper fit, making adjustments, and avoiding common mistakes. It offers guidance on belt placement for different outfits, matching belts with accessories, and adapting styles to various body types, ensuring that readers can wear belts with confidence and flair.

Proper care and maintenance of belts are crucial for longevity, and This book covers essential practices for cleaning, storing, and repairing belts. It provides advice on preventing wear and tear, helping readers extend the life of their belts and keep them looking their best.

For those interested in personalization, this book introduces DIY belt customization. It offers step-by-step instructions on tools, techniques, and

creative ideas for personalizing and adjusting belts, allowing readers to add their unique touch.

When it comes to purchasing belts, this book guides readers on identifying quality construction, understanding price versus value, and recognizing genuine brands. It compares online and in-store shopping options, helping readers make informed decisions.

This book also addresses the use of belts in various professional and recreational contexts, from work wear and sports to formal occasions. It provides insights into specialized belts for different needs, including safety and utility.

Finally, this book explores current trends and innovations in belt fashion, including technological advancements and sustainable options. It offers a forward-looking perspective on future trends, helping readers stay updated with the latest developments in belt design.

CHAPTER ONE

Introduction To Belts

Definition And Purpose Of Belts

Belts are versatile accessories used to secure clothing around the waist and enhance the overall outfit. Typically made from flexible materials, belts function primarily to hold up trousers, skirts, or dresses, ensuring they fit properly and remain in place throughout the day. Besides their practical use, belts also serve a decorative purpose, adding a stylish touch to an outfit. They can be used to define the waistline, create a more tailored appearance, or simply add a pop of color or texture to the ensemble.

In practical terms, a belt consists of a strap, often with a buckle or fastening mechanism at one end, which adjusts the fit around the waist.

The strap is threaded through loops on the garment, allowing the wearer to customize the fit and comfort. This functionality makes belts essential for both casual and formal wear, helping to prevent clothing from sagging or slipping.

Historical Evolution Of Belts

The history of belts dates back to ancient civilizations, where they were used not only as functional garments but also as symbols of status and power. In ancient Egypt, belts made from leather and adorned with intricate designs were worn by both men and women. Similarly, in medieval Europe, belts were not just practical items but also ornate accessories that signified social rank.

Over time, the design and use of belts evolved. During the Renaissance, belts became more decorative, incorporating precious metals and

gemstones. The Industrial Revolution brought about mass production, making belts more accessible and diverse in design. Today, belts come in various styles, materials, and functions, reflecting both their historical significance and contemporary fashion trends.

Different Types Of Belts

Belts come in numerous styles, each designed for specific functions and fashion statements. The most common types include:

1. **Dress Belts:** Typically made of leather, these belts are narrow and feature a sleek buckle. They are designed to complement formal wear, such as suits and dress pants.

2. **Casual Belts:** Often made from fabric, canvas, or distressed leather, casual belts are broader and come in a variety of colors and

patterns. They are ideal for everyday wear and casual outfits.

3. **Utility Belts:** These belts are equipped with various pouches and loops for carrying tools and equipment. They are commonly used in professions that require carrying multiple items, such as construction or law enforcement.

4. **Western Belts:** Characterized by their wide design and decorative buckles, Western belts are often associated with cowboy or country styles. They typically feature elaborate designs and are worn as a statement piece.

Each type of belt serves a specific purpose, and choosing the right one depends on the occasion, outfit, and personal style preferences.

Importance In Fashion And Functionality

Belts play a crucial role in both fashion and functionality. From a functional standpoint, belts are essential for ensuring that clothing fits properly and stays in place. They provide a customizable fit, allowing wearers to adjust their garments for comfort and practicality.

In terms of fashion, belts are a key accessory that can transform an outfit. They can create defined waistlines, add visual interest, and complement various styles. For instance, a wide belt can accentuate an hourglass figure, while a slim belt can add a touch of elegance to a dress. Belts also allow for creativity in fashion, with different colors, textures, and embellishments offering endless styling possibilities.

Overview Of Belt Materials

Belts are made from a wide range of materials, each offering unique characteristics and benefits. The most common materials include:

1. **Leather:** Known for its durability and classic appeal, leather belts are a staple in both formal and casual wardrobes. They come in various finishes, including smooth, textured, and distressed, and can be dyed in numerous colors.

2. **Fabric:** Fabric belts, made from materials like cotton, polyester, or nylon, are often used for casual wear. They are lightweight, flexible, and come in a variety of patterns and colors.

3. **Metal:** Some belts feature metal straps or buckles, adding a modern or edgy touch to the outfit. Metal belts are often used in fashion-

forward designs and can include materials such as stainless steel or brass.

4. **Synthetic Materials:** Synthetic belts, made from materials like faux leather or PVC, provide an affordable and animal-friendly alternative to traditional leather. They are available in many styles and can mimic the look of more expensive materials.

Understanding these materials helps in selecting the right belt for your needs, whether it's for durability, style, or specific functionality.

CHAPTER TWO

Choosing The Right Belt

Determining Your Belt Size

Choosing the right belt size is crucial for both comfort and style. To determine your correct belt size, start by measuring your waist. Use a flexible tape measure and wrap it around your waist where you normally wear your belt. Make sure the tape is snug but not too tight. Take note of the measurement in inches or centimeters.

Once you have your waist measurement, add 1 to 2 inches (or 2.5 to 5 cm) to account for the extra length needed for the belt buckle and to ensure a comfortable fit. This will give you your ideal belt length. For example, if your waist measures 34 inches, you should look for a belt that is between 35 and 36 inches.

Most belts are designed with multiple notches to adjust for varying waist sizes, so ensure you choose a belt with enough adjustment range.

When buying a belt, also consider the width. Standard belts are usually 1.25 to 1.5 inches wide, but this can vary based on fashion trends and personal preference. If you're unsure, it's always better to try on the belt or check the return policy before purchasing to ensure it fits comfortably and suits your needs.

Matching Belts With Outfits

Matching a belt with your outfit is a key aspect of styling. The general rule of thumb is to coordinate your belt with your shoes and other accessories. For formal occasions, opt for belts in classic colors like black, brown, or navy, which can easily match with dress shoes and tailored

trousers. A leather belt in a matching color to your shoes adds a touch of sophistication.

For casual outfits, you can experiment with different colors and materials. Fabric belts with colorful patterns or prints can add a fun element to jeans or chinos. When choosing a belt for a casual look, consider how it complements other elements of your outfit, such as your shirt or shoes. Belts can also be used as a statement piece, so don't be afraid to choose something that stands out if the occasion calls for it.

Additionally, belts with unique buckles or embellishments can be a focal point in more casual or fashion-forward outfits. Just ensure that the belt doesn't clash with the overall look and that it fits comfortably with the clothing you're wearing.

Types Of Belt Buckles And Their Uses

Belt buckles come in a variety of styles, each serving different functions and contributing to the overall aesthetic of your outfit. Traditional buckle styles include the frame buckle, which is the most common and straightforward, and the plate buckle, which has a larger, often decorative surface.

For a more modern look, consider a snap buckle or a sliding buckle, which offer a cleaner appearance and are often used in casual or utility belts. The snap buckle is particularly useful for belts that require frequent adjustments or quick removal, such as those used in outdoor activities or work wear.

If you're looking for a belt that can easily transition from casual to formal wear, a reversible buckle belt is a versatile option.

These belts feature buckles that can be flipped to change the belt's color or material, making it easier to coordinate with different outfits. For a high-fashion statement, look for decorative or novelty buckles that reflect your style.

Leather Vs. Fabric Belts: Pros And Cons

Leather and fabric belts each have their own set of advantages and disadvantages. Leather belts are known for their durability, classic look, and ability to age gracefully over time. They are ideal for formal and business settings where a polished appearance is important. Leather belts are also typically more resilient and can withstand daily wear better than fabric belts.

On the other hand, fabric belts offer more flexibility and a wider range of colors and patterns. They are often lighter and more comfortable, making them a great choice for

casual wear. Fabric belts are also easier to care for, as they can be washed or cleaned more easily than leather belts. However, they may not have the same longevity as leather belts and may wear out more quickly with frequent use.

Choosing between leather and fabric ultimately depends on the occasion and personal preference. For formal events and professional settings, leather belts are generally the better choice, while fabric belts can be perfect for casual, relaxed environments.

Tips For Selecting A Belt For Different Occasions

Selecting the right belt for an occasion requires understanding the dress code and the overall look you want to achieve. For formal events, such as business meetings or weddings, opt for a sleek leather belt in a neutral color that matches your

dress shoes. This will ensure a cohesive and polished appearance. Choose a belt with a simple, understated buckle to keep the focus on the outfit rather than the accessory.

For casual occasions, you have more freedom to experiment with different styles and materials. Fabric belts with patterns or bright colors can add a playful touch to your outfit. When choosing a casual belt, consider the type of pants you'll be wearing; for example, a canvas belt might be more suitable for chinos or shorts, while a braided leather belt can complement jeans.

For outdoor activities or work settings, durability and functionality become more important. Opt for belts made from sturdy materials like heavy-duty fabric or reinforced leather. These belts should feature a practical buckle that can withstand wear and tear.

Additionally, consider belts with features such as tool loops or additional pockets if you need extra utility.

CHAPTER THREE

Understanding Belt Materials

Leather: Types And Qualities

Understanding Leather Types

Leather belts are renowned for their durability and timeless appeal. The primary types of leather used for belts are full-grain, top-grain, and genuine leather. Full-grain leather is the highest quality, made from the top layer of the hide, retaining its natural texture and grain. This type is both strong and flexible, making it ideal for long-lasting belts. Top-grain leather is slightly less durable but still high-quality, as it is sanded and refinished to remove imperfections. Genuine leather, on the other hand, is made from the lower layers of the hide and is less durable but

more affordable. Each type has its unique characteristics and uses, with full-grain being the preferred choice for premium belts.

Selecting Leather Quality

When choosing a leather belt, consider factors such as thickness, finish, and treatment. Thicker leather belts are more durable and suitable for heavy-duty use, while thinner belts offer a sleeker, more refined look. The finish can vary from matte to glossy, affecting both appearance and texture. A well-treated leather belt should be smooth and even, without visible imperfections. To ensure the best quality, look for belts with solid stitching and high-quality buckles. Leather that feels supple and has a natural, pleasant smell is usually a good indicator of quality.

Crafting Your Leather Belt

Making your leather belt involves several steps. Start by selecting the right type of leather-based on your needs. Measure your waist and cut the leather strip to the desired length, typically 1 to 2 inches longer than your waist measurement. Use a belt buckle that complements your design and attach it using rivets or stitching. You can add holes for adjustment and ensure the belt fits comfortably. Finally, condition and polish the leather to enhance its appearance and longevity. This hands-on process allows you to create a customized belt that meets your personal style and functional needs.

Fabric: Varieties And Uses

Exploring Fabric Types

Fabric belts are versatile and come in various types such as cotton, nylon, and polyester.

Cotton belts are breathable and comfortable, making them ideal for casual wear. They are also easily washable, which adds to their practicality. Nylon belts are known for their strength and resistance to wear and tear, making them suitable for more rugged use. Polyester belts are durable and often used in both casual and formal settings due to their resistance to wrinkles and stains. Each fabric type offers different benefits and can be chosen based on the intended use of the belt.

Choosing Fabric for Belts

When selecting a fabric belt, consider the environment and activities where it will be worn. For daily wear and casual settings, cotton or polyester belts are excellent choices due to their comfort and ease of maintenance. If you require a belt for outdoor or heavy-duty use, nylon is a better option due to its strength and durability.

Fabric belts can also be designed with various patterns and colors, allowing for greater expression of personal style. Pay attention to the belt's width and length to ensure it fits well and complements your outfit.

Creating a Fabric Belt

Making a fabric belt involves cutting a piece of fabric to the desired length and width, usually with a bit of extra length to allow for adjustments. Sew or attach a buckle to one end of the fabric, and create a loop or mechanism to secure the other end. You can also add decorative elements such as embroidery or patches to personalize the belt. Fabric belts are relatively easy to make at home with basic sewing skills and tools. Once completed, the belt can be adjusted for fit and styled according to your preference.

Synthetic Materials: Advantages And Disadvantages

Understanding Synthetic Materials

Synthetic belts are made from man-made materials such as polyurethane (PU) and polyvinyl chloride (PVC). These materials are designed to mimic the appearance and feel of natural leather while offering some unique advantages. PU belts are known for their flexibility and resistance to cracking, making them a durable choice for everyday wear. PVC belts are water-resistant and easy to clean, which makes them suitable for various environments, including outdoor activities and wet conditions. Synthetic materials can be produced in a wide range of colors and textures, offering versatility in design.

Weighing the Pros and Cons

The advantages of synthetic belts include their affordability and low maintenance requirements. They are often less expensive than leather and can be cleaned with simple wipes or washes. However, synthetic belts may not offer the same level of breathability or durability as natural leather. They can also lack the unique texture and aging qualities of leather. Despite these drawbacks, synthetic belts are a practical choice for those seeking cost-effective and versatile options that still look stylish and perform well.

Making a Synthetic Belt

Creating a synthetic belt involves cutting the material to the desired length and width. Attach a buckle to one end using adhesive or stitching, depending on the material's compatibility. Some synthetic materials can be welded or heat-sealed,

providing a secure bond without sewing. Add holes or adjustment mechanisms as needed to ensure a good fit. Synthetic belts are relatively easy to make with basic tools and materials, and they offer the benefit of being low-maintenance and available in various styles.

Metal Belts And Their Applications

Exploring Metal Belts

Metal belts, often made from materials like stainless steel or aluminum, are known for their durability and modern aesthetic. These belts are often used in formal or professional settings due to their sleek appearance. Stainless steel belts are highly resistant to rust and corrosion, making them suitable for everyday wear and various environmental conditions. Aluminum belts are lighter but may require more care to prevent scratches and dents. Metal belts can also be

designed with intricate patterns and links, adding a touch of sophistication to any outfit.

Choosing Metal for Belts

When selecting a metal belt, consider factors such as weight, finish, and design. Stainless steel belts are ideal for their strength and longevity, while aluminum belts offer a lighter alternative. The finish can range from polished to brushed, affecting the overall look and feel of the belt. Ensure the belt is comfortable to wear and fits well by adjusting the length or links if necessary. Metal belts often come with adjustable mechanisms or removable links, allowing for customization to fit different waist sizes.

Crafting a Metal Belt

Making a metal belt involves assembling individual links or segments into a continuous band. Start by measuring your waist and cutting

the metal pieces to the required length. Use tools such as pliers and connectors to link the segments together securely. Attach a buckle or clasp that complements the design and ensures a comfortable fit. Metal belts may require more advanced tools and techniques compared to fabric or leather belts, but the result is a durable and stylish accessory that adds a unique touch to your wardrobe.

How To Care For Different Belt Materials

General Care Tips

Proper maintenance extends the life of your belts, regardless of material. For leather belts, regular conditioning with leather balm or oil keeps them supple and prevents cracking. Fabric belts benefit from gentle washing and air drying to maintain color and elasticity. Synthetic belts are easily

cleaned with mild soap and water, drying quickly without losing shape. Metal belts require occasional polishing to maintain their luster and prevent tarnishing.

Storage and Handling

Store belts in a cool, dry place away from direct sunlight to prevent fading or damage. Hanging belts on hooks or rolling them up avoids creases and maintains their shape. Avoid excessive bending or twisting, especially with leather belts, to preserve their integrity over time.

CHAPTER FOUR

Belt Design And Styles

Classic Belts: Features And Uses

Classic belts are the quintessential accessory for any wardrobe, known for their timeless style and functionality. Typically made from leather, classic belts feature a simple, elegant design that often includes a plain buckle or a modestly embellished one. These belts come in a range of colors, though black, brown, and tan are the most traditional and versatile options. Their primary use is to hold up trousers and provide a polished look, making them a staple in both formal and casual settings.

The construction of a classic belt usually involves high-quality leather, which is tanned and treated to ensure durability and a refined finish. The

belt's width is generally around 1.25 to 1.5 inches, making it suitable for most belt loops and styles of trousers. To create your classic belt, start by selecting a durable leather hide. Cut the leather to the desired length, ensuring it is slightly longer than your waist size to allow for adjustments. Use a belt buckle of your choice, attaching it with sturdy rivets or stitching for a secure fit. A belt hole punch is essential for creating adjustable holes at regular intervals.

Classic belts are highly functional, providing both style and support. When choosing a classic belt, consider the width and color that best match your wardrobe. For a polished look, ensure that the belt is well-maintained by conditioning the leather regularly and storing it properly to avoid damage. When wearing a classic belt, it should sit comfortably at your waist, with the buckle

aligned in the center of your torso for a balanced appearance.

Fashion Belts: Trends And Popular Styles

Fashion belts are all about making a statement and incorporating the latest trends into your wardrobe. Unlike classic belts, fashion belts come in a variety of materials, colors, and designs. Recent trends have seen the rise of wide belts that cinch the waist, often embellished with bold buckles or decorative elements. These belts can transform a simple outfit into a fashion-forward look, making them ideal for fashion enthusiasts.

Materials used in fashion belts range from luxurious leather and suede to unconventional fabrics like fabric prints and metallics. Popular styles include belts with oversized buckles, studded or chain details, and those with unique

prints or patterns. To create a fashion belt, start by selecting a fabric or material that aligns with current trends. Measure and cut the material to your desired width and length. Attach a statement buckle or embellishments that reflect the latest trends. If you're using a fabric belt, consider adding a layer of interfacing to provide structure and durability.

Fashion belts are versatile and can be used to accentuate various outfits, from high-waisted skirts and dresses to oversized blouses and trousers. They offer a way to showcase personal style and experiment with different looks. When incorporating a fashion belt into your wardrobe, ensure it complements your outfit without overwhelming it. Experiment with different styles to find what best suits your body shape and personal taste.

Functional Belts: Utility And Practicality

Functional belts are designed with practicality in mind, offering solutions for various needs beyond holding up trousers. These belts often feature additional pockets, tool holders, or even integrated gadgets, making them ideal for specific professions or activities. For instance, utility belts are common in fields like construction or security, where carrying essential tools and equipment is necessary.

A typical functional belt is made from durable materials like heavy-duty nylon or reinforced leather. It often includes multiple compartments, pouches, or loops for carrying tools, devices, or personal items. To make your functional belt, start by choosing a sturdy, adjustable strap material. Attach various pouches or compartments based on your needs, ensuring they are securely fastened and easy to access.

Reinforce the belt with additional stitching or rivets for added durability.

Functional belts provide immense utility in everyday tasks and specialized roles. For personal use, a functional belt can be customized to hold essentials like a phone, wallet, or keys. In professional settings, these belts enhance efficiency and organization. Ensure that the belt fits comfortably and securely around your waist, and regularly check the compartments and attachments for wear and tear to maintain its functionality.

Decorative Belts: Adding Flair To Your Outfit

Decorative belts are designed to enhance and personalize an outfit, adding a touch of flair and individuality. These belts often feature intricate designs, embellishments, or unique patterns that

make them stand out as a statement piece. Decorative belts can range from belts with ornate buckles and beaded details to those adorned with sequins or embroidered elements.

To create a decorative belt, start with a basic belt as the foundation. Choose a range of embellishments or decorative elements that suit your style, such as gemstones, sequins, or fabric appliqués. Arrange and attach these elements using fabric glue, stitching, or hotfix applicators, ensuring they are securely fixed. You can also experiment with different textures and colors to achieve a visually striking effect.

Decorative belts serve as an accessory to elevate an outfit, perfect for occasions where you want to stand out. They can be paired with simple dresses, blouses, or even pants to add a pop of color or texture. When designing a decorative belt, balance the embellishments with the rest of

your outfit to avoid overwhelming your look. Regularly check and maintain the decorations to ensure they remain intact and vibrant.

Belt Trends Across Different Decades

Belt trends have evolved significantly across different decades, reflecting changes in fashion and societal norms. In the 1920s, belts were often slim and functional, typically worn with high-waisted trousers and skirts. The 1950s saw the rise of wide, cinched belts that emphasized the hourglass figure, often adorned with oversized buckles or bow details. By the 1980s, belts became a statement accessory with bold colors and chunky designs, frequently worn over jackets and blazers.

To explore belt trends from different decades, examine historical fashion photos and collections to understand the defining features of each era.

For instance, 1990s belts often featured minimalist designs and were worn in a more relaxed, casual manner. To recreate or incorporate these trends into your wardrobe, start by selecting a belt style that matches the era you're inspired by. Consider materials, widths, and buckle designs characteristic of that time. Pair your belt with outfits that reflect the overall fashion trends of the chosen decade for an authentic look.

Understanding belt trends across different decades offers insights into how fashion evolves and inspires by incorporating vintage elements into modern wardrobes. Whether you're aiming for a retro-inspired look or just curious about fashion history, experimenting with these styles can add a unique touch to your outfits.

CHAPTER FIVE

How To Properly Wear A Belt

Proper Belt Fit And Adjustments

Achieving the perfect belt fit is essential for both comfort and style. The primary goal is to ensure that the belt sits snugly on your waist without being too tight or too loose. Start by selecting a belt that matches your waist size, which typically involves choosing a belt that is 1-2 inches larger than your waist measurement. For instance, if you wear a size 34 waist, opt for a belt in size 36.

When adjusting your belt, pay attention to the belt holes. Most belts come with several holes, allowing you to find the right fit. Ideally, the belt should be fastened in the middle hole, giving you flexibility for adjustments.

If your belt is too long, you can add additional holes using a belt hole puncher or have a professional tailor adjust it for you. This ensures that the excess belt material doesn't create a bulky look or hang loosely.

For a polished look, the belt should sit at the natural waistline. This is usually around the belly button. If you are wearing high-waisted trousers or skirts, the belt should be adjusted to match this higher position. Conversely, if your trousers sit lower on your hips, adjust the belt accordingly. The belt should lie flat against your clothing without causing bulges or discomfort. Proper fit ensures the belt complements your outfit and enhances your overall appearance.

Common Mistakes To Avoid

One of the most common mistakes when wearing a belt is choosing the wrong belt size. A belt that is too tight can cause discomfort, while one that is

too loose may not provide the necessary support or may look sloppy. Ensure you select a belt that fits your waist size and adjust it properly to avoid these issues. Additionally, avoid using belts that are too wide for the belt loops of your pants. A belt that is too wide can appear bulky and disrupt the clean lines of your outfit.

Another mistake is wearing belts that clash with the rest of your outfit. For example, a belt that contrasts sharply with your shoes or accessories can disrupt the visual harmony of your look. Aim for coordination, such as matching your belt to your shoes or other accessories, to create a cohesive appearance. Additionally, be cautious of wearing belts with excessive ornamentation or flashy buckles for formal occasions; opt for simpler designs that enhance rather than distract from your outfit.

Lastly, don't neglect the importance of belt placement. Wearing the belt too high or too low can disrupt the balance of your outfit. For a streamlined look, the belt should align with your natural waistline or the waistline of your trousers or skirt. Ensure the belt is visible but not overly prominent, allowing it to complement your outfit rather than overpower it.

Belt Placement For Different Outfits

Belt placement is crucial in achieving a well-balanced outfit. For formal attire, such as suits or dress pants, the belt should be placed at your natural waistline. This helps maintain a sleek silhouette and ensures the belt complements the formality of your clothing. Choose a belt that is simple and understated, typically in a color that matches or complements your shoes.

For casual outfits, such as jeans or casual trousers, you have more flexibility in belt placement. You can opt for a lower belt placement, often at the hips, especially if you are wearing a relaxed-fit pair of jeans. This placement creates a laid-back look and is often more comfortable for everyday wear. Casual belts can feature more varied designs, including patterns and brighter colors, allowing you to express personal style.

When wearing a belt with dresses or skirts, the placement should enhance the garment's silhouette. For high-waisted skirts or dresses, position the belt at the natural waistline to emphasize the waist and create an hourglass shape. For lower-waisted skirts, adjust the belt to align with the skirt's waistband. This approach helps define your figure and adds a fashionable touch to your outfit.

How To Match Belts With Accessories

Matching belts with accessories requires a keen eye for coordination and balance. Start by considering the color and material of your belt about your other accessories. For example, if you are wearing brown leather shoes and a brown leather belt, ensure that the belt's color and finish closely match the shoes for a unified look. This principle applies to other accessories such as bags and watch bands.

When coordinating with metal accessories, such as buckles, belts, and jewelry, aim for consistency in the metal tones. For instance, if your belt has a gold buckle, choose gold-toned jewelry and accessories to maintain a cohesive appearance. Avoid mixing too many different metal colors, as this can create visual clutter and detract from the elegance of your outfit.

For belts with patterns or unique designs, balance them with simpler accessories. If you wear a belt with a bold pattern or intricate buckle, opt for more subdued accessories to avoid overwhelming your look. Conversely, if your belt is simple and understated, you can experiment with more elaborate accessories to create visual interest.

Belt-Wearing Tips For Different Body Types

Choosing the right belt for your body type can enhance your overall appearance and comfort. For individuals with a larger waist, opt for belts that are wider and more substantial. This helps in distributing the weight more evenly and provides better support. Avoid belts that are too narrow, as they can appear out of proportion and may not offer the necessary support.

For those with a slimmer waist, thinner belts can be more flattering. They help to accentuate the waist without adding bulk. Additionally, consider belts with subtle designs or minimal embellishments to maintain a sleek and refined look. Avoid overly wide belts, as they may overwhelm a smaller frame.

For individuals with an athletic build, belts that are neither too wide nor too narrow work best. Choose belts that complement your physique without drawing too much attention. Opt for belts in neutral colors or patterns that align with your wardrobe. Additionally, belts with adjustable features can be beneficial for accommodating different outfits and styles.

By following these guidelines, you can effectively wear belts to enhance your style, ensuring they complement your outfits and suit your body type.

CHAPTER SIX

Belt Care And Maintenance

Cleaning Leather Belts

Leather belts are a staple in many wardrobes, valued for their durability and timeless style. However, to keep them looking their best, proper cleaning and maintenance are essential. Begin by removing any loose dirt or debris using a soft, dry cloth or a gentle brush. This will help prevent any abrasive particles from scratching the leather during the cleaning process.

Next, use leather cleaner specifically designed for belts. Apply a small amount of the cleaner to a clean, damp cloth and gently rub it into the leather using circular motions. Avoid applying the cleaner directly to the belt to prevent over-saturation.

Once the cleaner has been evenly applied, wipe away any excess with a dry cloth. For deeper cleaning, you may need to repeat the process or use a leather conditioner to restore moisture.

After cleaning, allow the belt to air dry naturally, away from direct sunlight or heat sources, which can cause the leather to crack. Once dry, apply a leather conditioner to keep the leather supple and prevent it from drying out. Simply apply a small amount of conditioner to a clean cloth and rub it into the leather in circular motions. This will help maintain the belt's flexibility and sheen, ensuring it continues to look and feel good.

Storing Belts Properly

Proper storage of belts is crucial for maintaining their shape and longevity. Avoid hanging belts on hooks or nails, as this can cause them to stretch or become misshapen. Instead, use a belt rack or

a dedicated storage solution that allows the belts to hang freely without any pressure on their structure. If you prefer to store them in drawers or boxes, make sure they are laid flat or rolled gently to prevent creases and deformities.

For leather belts, consider using a breathable fabric bag or wrapping them in tissue paper to protect them from dust and moisture. Ensure that the storage area is cool, dry, and away from direct sunlight to prevent damage from heat or UV rays. Additionally, avoid storing belts in damp or humid environments, as this can lead to mold or mildew growth.

For fabric belts or belts with intricate designs, consider using dividers or individual compartments to keep them organized and prevent tangling. This will also help you quickly locate the belt you need without disturbing the rest of your collection. Proper storage not only

keeps your belts in excellent condition but also extends their lifespan.

Repairing Common Belt Issues

Belts can encounter various issues over time, but many of these problems can be easily repaired with a few simple techniques. One common issue is a worn-out or broken buckle. To repair a damaged buckle, you may need to replace it entirely. Buckles can be purchased separately from hardware stores or online retailers. Simply detach the old buckle from the belt and attach the new one using the provided screws or clasps.

Another common issue is a belt that has become too loose or too tight. To adjust the size, you can add or remove belt holes using a hole punch tool. Place the belt on a flat surface, measure and mark the desired location for the new hole, and carefully punch through the leather. For a more

precise fit, you might need to seek professional help or consider having the belt resized by a leatherworker.

For minor scratches or scuffs, use a leather repair kit that includes a leather filler or polish. Apply the filler according to the instructions on the kit, using a small brush or applicator to blend the filler with the surrounding leather. Once the repair is dry, apply a leather conditioner to restore the belt's original texture and shine.

Preventing Wear And Tear

Preventing wear and tear on your belts involves a combination of careful use and regular maintenance. Avoid over-tightening belts, as this can cause undue stress on the leather or fabric and lead to premature wear. Instead, adjust the belt to fit comfortably without excessive tension. Additionally, be mindful of how you store your

belts, as improper storage can contribute to damage over time.

Regular cleaning and conditioning are also key to preventing wear and tear. Leather belts, in particular, require periodic conditioning to maintain their flexibility and prevent cracking. Fabric belts should be cleaned according to the manufacturer's instructions to avoid damage. Addressing stains or spills promptly can also prevent long-term damage and keep your belts looking their best.

If you notice any signs of wear, such as fraying edges or loose stitching, address these issues promptly to prevent further damage. For belts with fabric components, use a fabric sealant to protect against fraying or unraveling. Regularly inspecting and caring for your belts will help you identify and address potential issues before they become more significant problems.

Extending The Life Of Your Belts

To extend the life of your belts, follow a comprehensive care routine that includes cleaning, proper storage, and timely repairs. Start by regularly cleaning your belts to remove dirt and oils that can degrade the material over time. For leather belts, apply a conditioner every few months to keep the leather hydrated and prevent cracking. For fabric belts, ensure they are free from stains and debris.

Proper storage is also crucial for extending the life of your belts. Store them in a cool, dry place away from direct sunlight and heat sources. Use appropriate storage solutions, such as belt racks or fabric bags, to prevent deformation and damage. Avoid folding or creasing belts, as this can lead to permanent marks or weak spots.

Finally, address any minor issues promptly to prevent them from escalating. Repair loose stitching, replace broken buckles, and address any signs of wear as soon as they appear. By maintaining a regular care routine and being proactive about repairs, you can significantly extend the lifespan of your belts and keep them looking great for years to come.

CHAPTER SEVEN

DIY Belt Customization

Tools And Materials Needed

To embark on DIY belt customization, having the right tools and materials is crucial. Start with a basic toolkit, which includes a sharp pair of scissors or a rotary cutter, a ruler or measuring tape, and a strong, durable adhesive suitable for leather or fabric, depending on your belt material. You'll also need a hole punch for adding extra holes and a belt buckle or decorative hardware if you're changing the buckle. For fabric belts, a sewing machine or needle and thread are essential. Leather belts might require leather-specific tools like a leather punch and edge burnisher.

Additionally, gather any decorative elements you wish to use. These could include fabric paint, rhinestones, beads, patches, or appliqués. A craft knife or scalpel can help in intricate detailing, and fabric glue or hot glue gun can assist in attaching embellishments. Finally, if you plan to dye or paint your belt, obtain suitable dyes or paints for the material. Keeping these tools organized will streamline your customization process and ensure you have everything at hand when you begin.

Simple Techniques For Personalizing Belts

Personalizing a belt can be a straightforward process, starting with the basics. One of the simplest methods is to paint or dye your belt. If you are working with a leather belt, use leather-specific paint or dye. Start by cleaning the belt thoroughly to remove any dirt or oils.

Apply the paint with a brush, sponge, or even a sponge dauber, ensuring even coverage. Allow the paint to dry completely before handling or wearing the belt.

Another easy technique is to use fabric markers or paints on fabric belts. Lay the belt flat and ensure the surface is clean and dry. Sketch your design lightly with a pencil before applying the paint or marker. For a more professional finish, consider using a stencil to achieve precise shapes and patterns. Once you're satisfied with the design, set the paint according to the manufacturer's instructions, which often involves heat-setting the paint with an iron.

Adding Decorative Elements

Adding decorative elements can dramatically enhance the appearance of your belt. Start by deciding on the type of embellishments you want,

such as studs, rhinestones, or fabric patches. For leather belts, you can use a hole punch to make holes where you will place studs or rivets. Apply a small amount of adhesive to the back of each decorative element and press it firmly into place, ensuring it is securely attached. For added durability, you can use a small hammer or mallet to set rivets into the leather.

Fabric belts offer more flexibility for embellishments. Sew on patches or appliqués using a sewing machine or hand stitches. For an even more personalized touch, you can add fabric flowers, lace, or embroidery. If using adhesive for fabric embellishments, make sure it is fabric-safe and strong enough to hold the elements in place. Allow any glue to dry completely before wearing or using the belt.

Adjusting Belt Length At Home

Adjusting the length of a belt at home can be done with relative ease, depending on the type of belt you are working with. For leather belts, you will need to remove the buckle first. Using a sharp utility knife or rotary cutter, trim the excess length from the belt. Make sure to cut straight and measure accurately to avoid making the belt too short. After cutting, reattach the buckle and use a hole punch to create new holes for the belt buckle to fit.

For fabric belts, you may need to sew the belt to the desired length. Start by marking where you want to shorten the belt and cut off the excess material. Fold the raw edges to prevent fraying and sew them in place, or use fabric glue to secure the edges. Ensure the belt is still comfortable and fits properly before finalizing the changes. If the belt has a buckle that needs

adjusting, you may need to reposition it by sewing or gluing it in place.

Ideas For Creative Belt Projects

Creative belt projects can turn an ordinary belt into a unique fashion statement. Consider designing a belt with a mix of materials, such as combining leather with fabric or adding metallic accents. For a trendy look, try creating a belt with a fabric base and attaching decorative patches or embroidery. Another idea is to create a reversible belt with different patterns or colors on each side, offering versatility in your wardrobe.

You can also transform old belts into new accessories. For example, use a belt to make a stylish dog collar or a decorative headband. Cut the belt into smaller strips to create unique bracelets or keychains.

Experiment with different techniques like weaving, braiding, or adding custom charms. By thinking outside the box and combining various materials and embellishments, you can create bespoke accessories that reflect your style.

CHAPTER EIGHT

Buying Belts: What To Look For

Identifying Quality Belt Construction

When selecting a belt, the construction quality is paramount. Start by examining the material. Leather belts should be made from full-grain or top-grain leather, which is durable and develops a unique patina over time. Full-grain leather, the highest quality, comes from the top layer of the hide and retains the natural grain, making it resistant to wear. Top-grain leather, slightly lower in quality, is sanded and polished but still offers good durability. For synthetic belts, look for high-grade faux leather or materials designed to mimic leather closely.

Check the belt's stitching. High-quality belts feature precise, even stitches without loose

threads. Double stitching or reinforced stitching around the buckle area is an indicator of a durable belt. The edges of the belt should be smooth and burnished, not rough or uneven. Additionally, pay attention to the buckle attachment. A high-quality belt has a securely attached buckle with screws or rivets, not just glued or tacked on. A well-constructed belt will have a sturdy, functional buckle that doesn't wobble or feel flimsy.

Finally, assess the belt's overall feel. A good-quality belt should feel substantial in your hands, not flimsy or overly flexible. It should also be comfortable when worn, with no visible signs of peeling or damage. When you bend or twist the belt, it should return to its original shape without any creases or warping.

These physical characteristics are indicators of a belt that is built to last.

Evaluating Belt Price Vs. Value

Price often reflects quality, but it's essential to understand the relationship between price and value when buying a belt. Expensive belts are not always the best, and cheap belts may not offer good value. Start by setting a budget based on your needs and how often you plan to use the belt. For everyday wear, investing in a mid-range belt made from quality leather or a reputable synthetic material can provide a good balance of durability and cost.

Consider the cost per wear. A higher-priced belt made from durable materials might seem expensive upfront but can offer better value over time as it lasts longer and requires fewer replacements.

Conversely, a cheaper belt may initially save money but could wear out quickly, leading to

more frequent replacements and potentially higher costs in the long run.

Check for additional features that may justify a higher price, such as adjustable sizing, interchangeable buckles, or special finishes. Sometimes, paying a bit more for these features can enhance the belt's versatility and lifespan. Always read customer reviews and ratings to gauge if the belt lives up to its price. Value is not just about the price tag but about the overall satisfaction and longevity of the product.

Understanding Brand Differences

Brand reputation can significantly influence your belt purchase decision. Renowned brands often invest in better materials and craftsmanship, which can result in a more durable and stylish belt. However, this doesn't mean lesser-known brands don't offer quality products.

Research brands to understand their history, customer feedback, and material sourcing. Brands known for high-quality belts typically have consistently positive reviews and a track record of reliable products.

Compare the belt construction and design between different brands. Established brands often offer a range of styles and customizations, ensuring you can find a belt that fits both your aesthetic and practical needs. Additionally, branded belts might come with warranties or guarantees, offering added peace of mind. Check the brand's website or consult customer service for details on their quality assurance practices and any after-sales support.

On the other hand, new or lesser-known brands can provide excellent value and innovation at a lower cost. Look for reviews and testimonials to evaluate their quality. Sometimes, these brands

use similar materials and manufacturing processes as well-known ones but at a more competitive price. Understanding brand differences helps you make an informed choice and ensures that you select a belt that meets your expectations in terms of style, quality, and value.

Where To Buy Belts: Online Vs. In-Store

Choosing between buying a belt online or in-store depends on your preferences and needs. In-store shopping allows you to physically inspect and try on the belt, ensuring a proper fit and feel. You can assess the belt's quality firsthand, check its construction, and make immediate comparisons with other options. Additionally, store staff can offer personalized advice and help you find a belt that suits your style and requirements.

Online shopping offers convenience and often a wider selection. You can compare various brands

and styles from the comfort of your home. Many online retailers provide detailed product descriptions, customer reviews, and sizing guides to assist you in making an informed decision. However, buying online does carry the risk of receiving a product that doesn't match its description or fit as expected. Ensure the online store has a good return policy to address any issues with your purchase.

When buying online, consider reputable retailers and read customer feedback to gauge product quality. Check if the retailer offers free returns or exchanges, which can mitigate the risk of ending up with a belt that doesn't meet your expectations. Whether buying in-store or online, always ensure you are purchasing from a trustworthy source to avoid counterfeit or low-quality products.

Signs Of A Genuine Belt

Identifying a genuine belt involves checking for specific characteristics that distinguish it from counterfeit or imitation products. For leather belts, the most telling sign of authenticity is the quality of the leather. Genuine leather will have natural imperfections, such as slight variations in texture and color, while synthetic materials may look overly uniform. A genuine leather belt should have a distinct leather smell, not a chemical or plastic odor.

Examine the stitching and hardware. A genuine belt typically has precise, even stitching and high-quality hardware such as a solid metal buckle. Look for any branding or logos on the buckle or belt.

Authentic belts from reputable brands will have clear, well-made logos and embossing, while

counterfeit belts might have poorly done or misspelled branding.

Lastly, consider the price and source. Genuine belts from reputable brands are usually priced within a specific range, so extremely low prices can be a red flag. Buy from authorized retailers or the brand's official store to ensure the authenticity of the belt. Be cautious of deals that seem too good to be true, as they often indicate counterfeit or subpar products.

CHAPTER NINE

Belts For Different Professions And Activities

Belts For Work wear And Uniforms

Introduction

Work wear and uniforms often require belts that are durable, functional, and sometimes adjustable for comfort during long hours of use. Whether you're in construction, hospitality, or healthcare, choosing the right belt can enhance both comfort and efficiency.

Choosing the Right Belt

When selecting a belt for work wear or uniforms, consider the material and functionality. For heavy-duty jobs like construction, a sturdy

leather belt with a robust buckle provides durability and strength. Look for belts with double stitching or reinforced sections to handle tools or equipment pouches without sagging or tearing.

Practical Application

To ensure comfort, adjustable belts with easy-to-operate buckles are ideal. Belts that allow for quick adjustments are essential for varying waist sizes due to clothing layering or weight fluctuations during long shifts. For instance, in healthcare settings, where movement and comfort are crucial, elastic or stretchable belts provide flexibility without compromising on support.

DIY Tips

For those wanting a custom solution, making your work belt can be straightforward. Start by selecting a heavy-duty fabric or leather that suits your profession's demands. Measure your waist and cut the material accordingly, leaving extra length for adjustments. Attach a durable buckle securely using rivets or strong stitching to ensure it withstands daily wear and tear.

Belts For Sports And Outdoor Activities

Introduction

Sports and outdoor activities demand belts that offer flexibility, comfort, and often specialized features for various environments. Whether hiking, climbing, or playing sports, the right belt can enhance performance and safety.

Choosing the Right Belt

For active pursuits, lightweight and breathable materials like nylon or polyester are ideal choices. These materials provide flexibility and moisture-wicking properties, crucial for comfort during intense physical activities. Look for belts with low-profile buckles to prevent discomfort during movements or when wearing a backpack.

Practical Application

In sports, belts often serve dual purposes, such as securing gear or supporting the body during strenuous movements. Belts designed for hiking, for example, may feature quick-release buckles for easy adjustments on the trail. Meanwhile, in water sports, waterproof belts with corrosion-resistant hardware are essential to withstand exposure to moisture.

DIY Tips

Creating a sports or outdoor belt can be rewarding. Opt for materials that are water-resistant and durable, such as webbing or outdoor-grade fabrics. Ensure the belt is adjustable to accommodate different layers of clothing or gear. Incorporate features like D-rings or carabiner loops for attaching equipment, enhancing the belt's utility in various outdoor scenarios.

Fashion Belts For Social Events

Introduction

Fashion belts for social events serve both decorative and practical purposes, enhancing outfits while providing a touch of personal style. From weddings to parties, choosing the right belt can elevate your ensemble.

Choosing the Right Belt

Fashion belts come in various styles and materials, ranging from classic leather to embellished designs. Consider the formality of the occasion and the outfit when selecting a belt. A sleek leather belt with a minimalist buckle complements formal attire, while a statement belt with metallic accents adds flair to casual outfits.

Practical Application

In social settings, belts serve as focal points or complementary accessories. For men, coordinating the belt with shoes and other accessories creates a polished look. Women can use belts to define the waistline or add contrast to their attire. Flexible sizing options and adjustable closures ensure comfort throughout the event.

DIY Tips

Creating a fashion belt allows for personalization. Choose materials and embellishments that match your style preferences. Experiment with different textures or colors to coordinate with your wardrobe. Consider adding unique features like embroidery or beadwork for a bespoke touch that stands out at social gatherings.

Belts For Formal Occasions

Introduction

Belts for formal occasions should complement formal attire while providing comfort and elegance. Whether attending a gala or a business event, choosing the right belt ensures a cohesive and polished appearance.

Choosing the Right Belt

Opt for classic materials such as leather or suede in neutral tones like black, brown, or navy. These colors are versatile and pair well with traditional formalwear. Look for belts with subtle or ornate buckles depending on the formality of the event, ensuring they complement rather than overpower the ensemble.

Practical Application

Formal belts should be understated yet sophisticated, seamlessly integrating with tailored suits or evening gowns. Pay attention to details like width and texture to harmonize with the outfit's overall aesthetic. Adjustable sizing ensures a proper fit that enhances comfort without detracting from the formal look.

DIY Tips

Crafting a formal belt allows for customization. Select high-quality leather or suede for a luxurious feel. Focus on precision when cutting and stitching to achieve clean lines and durability. Incorporate classic buckle designs or opt for minimalist closures to maintain a timeless appeal. Personalize with monograms or subtle embossing for a bespoke touch.

Specialized Belts For Safety And Utility

Introduction

Specialized belts for safety and utility are essential in professions where safety and functionality are paramount. From utility belts for technicians to safety harnesses for industrial settings, these belts ensure both protection and efficiency.

Choosing the Right Belt

Safety and utility belts should meet industry standards for durability and safety features. Materials like reinforced nylon or polyester webbing provide strength and resilience against wear and tear. Look for belts with secure closures and adjustable fittings to accommodate safety gear or tool attachments.

Practical Application

In industrial or technical settings, belts serve as anchorage points for equipment or safety harnesses. Ergonomic designs distribute weight evenly, reducing strain during prolonged use. Reflective or high-visibility belts enhance visibility in low-light conditions, ensuring safety in hazardous environments.

DIY Tips

Creating a specialized safety or utility belt requires adherence to safety standards. Use industrial-grade materials that withstand rigorous conditions. Reinforce stress points with double stitching or rivets for added durability. Customize belt features such as tool loops or attachment points based on specific job requirements to optimize functionality and safety.

CHAPTER TEN

Belt Trends And Innovations

Current Trends In Belt Fashion

In the world of fashion, belts have evolved beyond their functional purpose to become key style elements. Currently, the fashion trend for belts is characterized by a blend of classic and contemporary styles. Wide belts are making a strong comeback, often used to accentuate the waistline on dresses and high-waisted pants. These belts are not only practical but also serve as statement pieces that can transform an outfit. Look for wide belts made from materials like leather or fabric with intricate designs or metallic accents to make a bold fashion statement.

Another trend is the use of embellished belts. These belts often feature decorative elements

such as studs, rhinestones, or embroidery, adding a touch of glamour to both casual and formal outfits. For a chic and modern look, consider belts with unique buckle designs or color contrasts that stand out against the clothing. Belts in vibrant colors or with eye-catching patterns are also popular, providing an easy way to inject some personality into an outfit.

Belts are also being used creatively to redefine traditional silhouettes. Designers are experimenting with unconventional belt placements, such as belts worn over outerwear or as part of layered looks. This trend involves using belts to cinch oversized coats or blazers, creating a more tailored appearance. To incorporate these trends, you can experiment with different belt widths, textures, and colors, ensuring they complement the overall aesthetic of your wardrobe.

Technological Innovations In Belt Design

Technological advancements are reshaping belt design, and introducing new features that enhance both functionality and style. One notable innovation is the development of smart belts. These belts come equipped with technology that can track fitness metrics such as steps taken and calories burned. Integrated sensors within the belt provide real-time feedback, which can be synced with smartphone apps for detailed analysis. Smart belts offer a convenient way to stay on top of health goals while maintaining a fashionable appearance.

Another exciting innovation is the use of 3D printing in belt manufacturing. 3D printing allows for the creation of complex, customized belt designs that were previously difficult or impossible to produce. This technology enables designers to experiment with intricate patterns, textures, and shapes, resulting in unique and personalized belts. The ability to print belts on demand also reduces waste, making the process more sustainable.

Adjustable belts with innovative buckle mechanisms are also gaining popularity. These belts feature buckles that allow for precise adjustments without the need for traditional belt holes. Some designs include magnetic closures or ratchet systems that offer a snug fit and easy adjustments. These technological advancements make it simpler to achieve a comfortable fit and add a modern touch to the classic belt design.

Sustainable And Eco-Friendly Belt Options

Sustainability is becoming a crucial aspect of fashion, and the belt industry is no exception. Many brands are now offering eco-friendly belt options made from recycled or organic materials. Recycled leather belts, for instance, are created from repurposed leather scraps, reducing waste and minimizing the environmental impact of production. These belts maintain the durability and aesthetic appeal of traditional leather belts while promoting a more sustainable approach.

Another eco-friendly option is belts made from alternative materials such as cork or hemp. Cork belts are produced from the bark of cork oak trees, a renewable resource that requires minimal environmental impact. Hemp belts are made from one of the most sustainable plant fibers, known for its strength and durability.

These materials are not only environmentally friendly but also offer unique textures and styles.

Vegan leather belts are also gaining traction as a cruelty-free alternative to traditional leather. Made from synthetic materials such as polyurethane or plant-based alternatives, vegan leather belts provide a stylish and ethical choice. Brands are increasingly incorporating innovative processes to create high-quality vegan leather that mimics the look and feel of real leather without the use of animal products.

Future Trends In Belt Materials And Design

Looking ahead, several trends are anticipated to shape the future of belt materials and design. One emerging trend is the use of advanced materials that offer both functionality and aesthetics.

For example, belts made from flexible, durable materials like silicone or high-tech fabrics are gaining popularity. These materials offer increased comfort, resistance to wear and tear, and the ability to maintain their shape over time.

Another future trend is the integration of technology in belt design. We can expect to see more belts incorporating smart features, such as embedded LEDs for visibility or interactive elements that sync with wearable tech. These innovations will not only enhance the functionality of belts but also contribute to their role as stylish accessories.

Customization will also play a significant role in future belt trends. Advances in technology will allow for greater personalization, enabling consumers to create bespoke belts tailored to their individual preferences. This trend includes customizable colors, patterns, and buckle designs,

providing a unique and personal touch to every belt.

How To Stay Updated With Belt Trends

To stay updated with the latest belt trends, it's essential to keep an eye on fashion industry news and follow relevant fashion influencers. Fashion magazines, blogs, and online platforms are valuable sources of information on current trends and emerging styles. Subscribing to fashion newsletters or joining fashion communities can also provide regular updates and insights.

Attending fashion shows or events is another way to stay informed about new trends. These events often showcase the latest collections from designers and offer a glimpse into upcoming trends. Additionally, exploring online retailers and fashion brands' websites can provide a preview of new releases and seasonal collections.

Social media platforms, particularly Instagram and Pinterest, are excellent resources for discovering the latest belt trends. Following fashion influencers and brands can offer inspiration and keep you updated on popular styles and innovative designs. Engaging with these platforms will help you stay ahead of trends and incorporate the latest belt styles into your wardrobe.

CONCLUSION

In the vast and varied world of fashion and functionality, belts stand out as a remarkable accessory that bridges the gap between utility and style. Throughout history, belts have evolved from simple strips of leather used for practical purposes to sophisticated pieces of fashion that express personal style and cultural identity. This evolution highlights not only their enduring relevance but also their adaptability to changing trends and societal norms.

Belts serve multiple functions, with their primary purpose being to secure garments, particularly trousers, at the waist. This practical use ensures that they remain a staple in wardrobes worldwide. However, their role extends far beyond mere functionality. In contemporary fashion, belts are celebrated for their ability to enhance and define silhouettes, add visual

interest, and provide a finishing touch to various outfits. Whether used to cinch a blazer, accentuate a dress, or simply add a touch of flair, belts have become a versatile accessory that complements and elevates any ensemble.

Moreover, belts have significant cultural and historical significance. From the elaborate, ornate belts worn by ancient civilizations to the minimalist designs of modern fashion, they reflect the aesthetic values and technological advancements of their times. This historical perspective not only enriches our understanding of fashion but also emphasizes the belt's role in cultural expression and personal identity.

The variety of belt styles available today—from classic leather to trendy wide belts, and from casual fabric belts to luxurious designer pieces—demonstrates their capacity to adapt to and influence fashion trends. Each style brings its

own set of characteristics and uses, allowing individuals to choose belts that align with their personal taste and functional needs. This diversity ensures that belts remain relevant and fashionable, regardless of changes in fashion cycles.

In conclusion, belts are far more than just functional accessories; they are dynamic elements of fashion that offer both practical benefits and aesthetic value. Their ability to transform an outfit, convey cultural significance and reflect personal style makes them an indispensable part of modern wardrobes. As fashion continues to evolve, belts will undoubtedly remain a crucial accessory, symbolizing both timeless utility and contemporary elegance. Their enduring appeal lies in their unique combination of form and function, proving that even the simplest

accessories can have a profound impact on fashion and self-expression.

THE END

www.ingramcontent.com/pod-product-compliance
Lightning Source LLC
Chambersburg PA
CBHW071834210526
45479CB00001B/129